Currado Malaspina's
PALIMPSESTE
VOLUME ONE

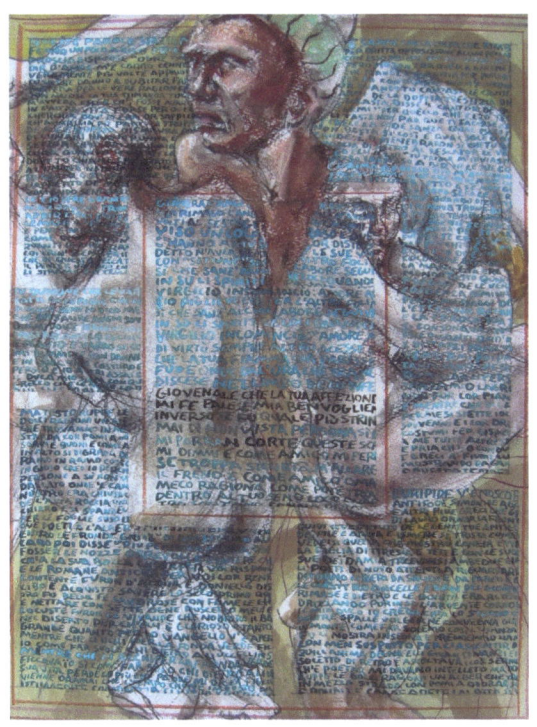

text by Dahlia Danton

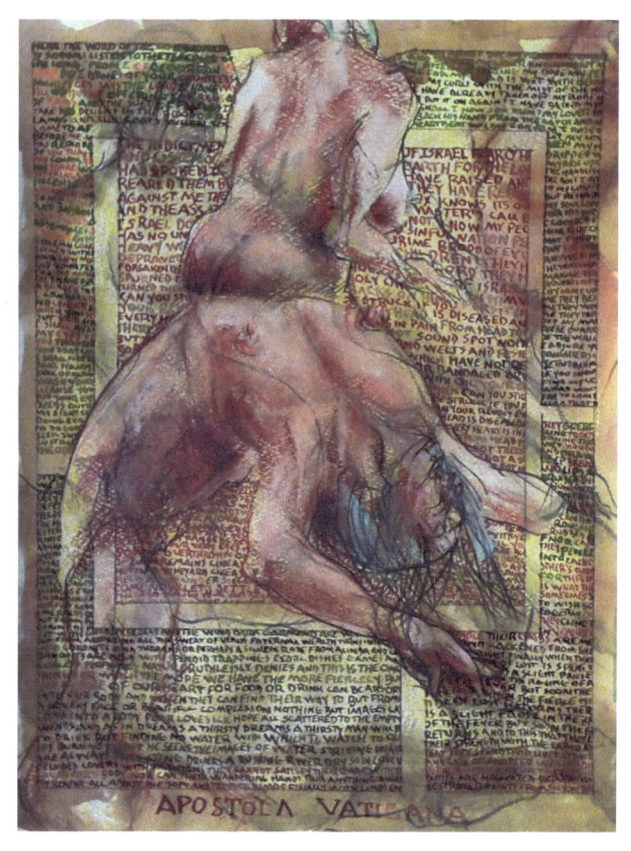

Currado Malaspina woke up on the morning of his 50th birthday

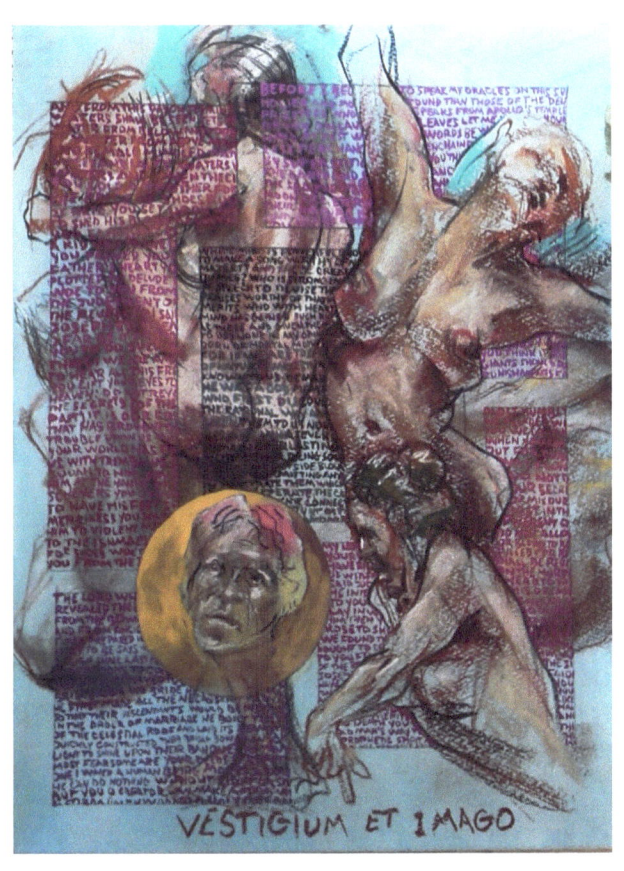

with the terrifying realization that he had yet to win a Nobel Prize.

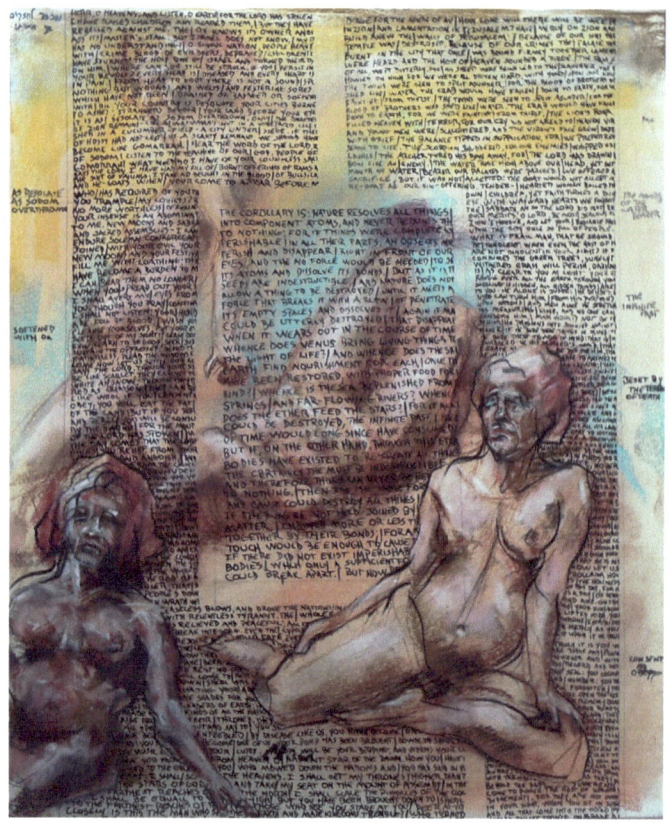

This was no idle daydream

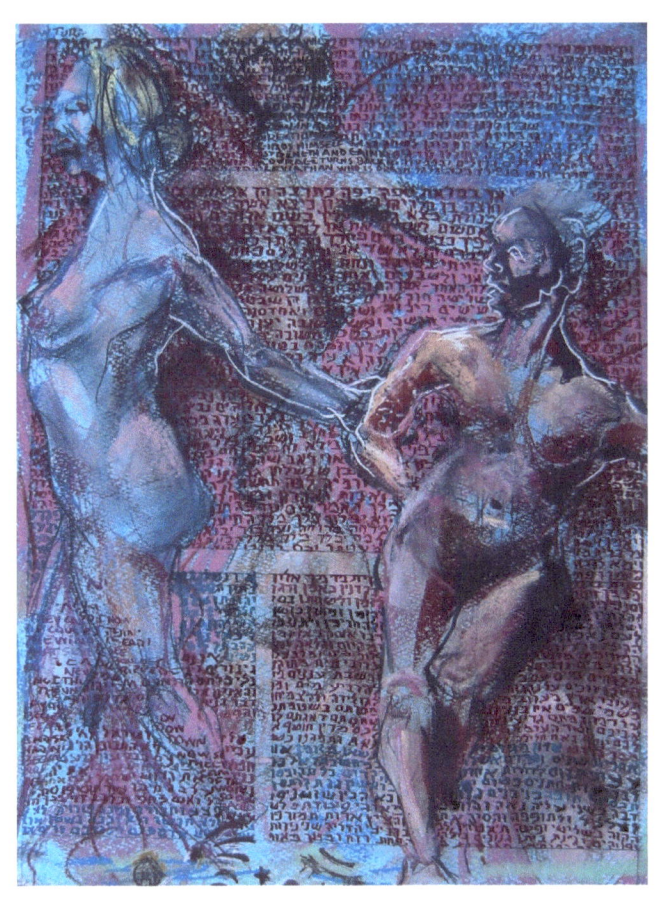

or a weakening of an already tenuous grasp on rationality.

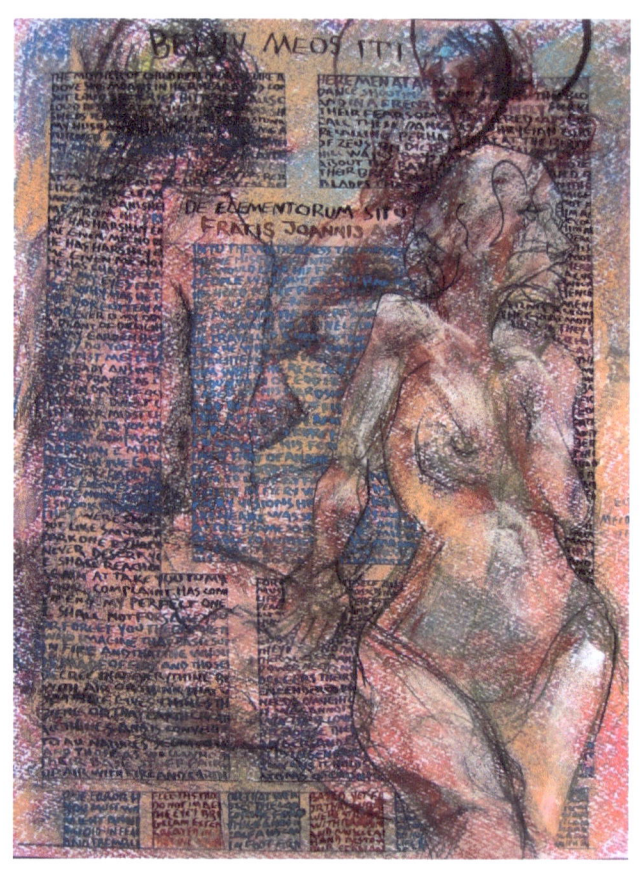

He had already won just about every significant prize the Republic of France bestows upon its artists

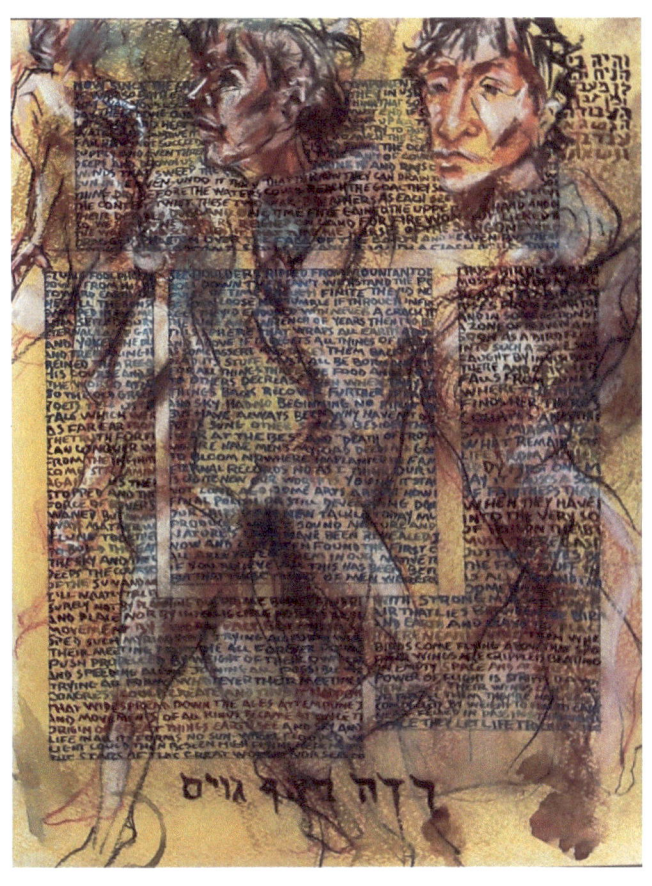

including the Grand'croix du Mérite, the Chevalier d'Ordre des Arts et des Lettres and the coveted Prix Laval for artistic collaboration.

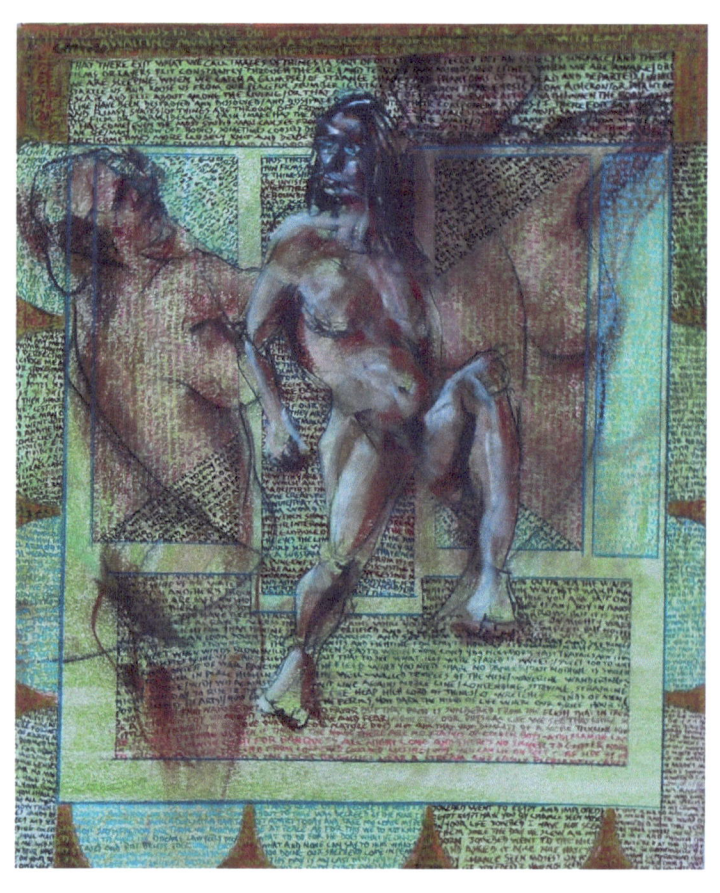

It only seemed just that he also win a Nobel

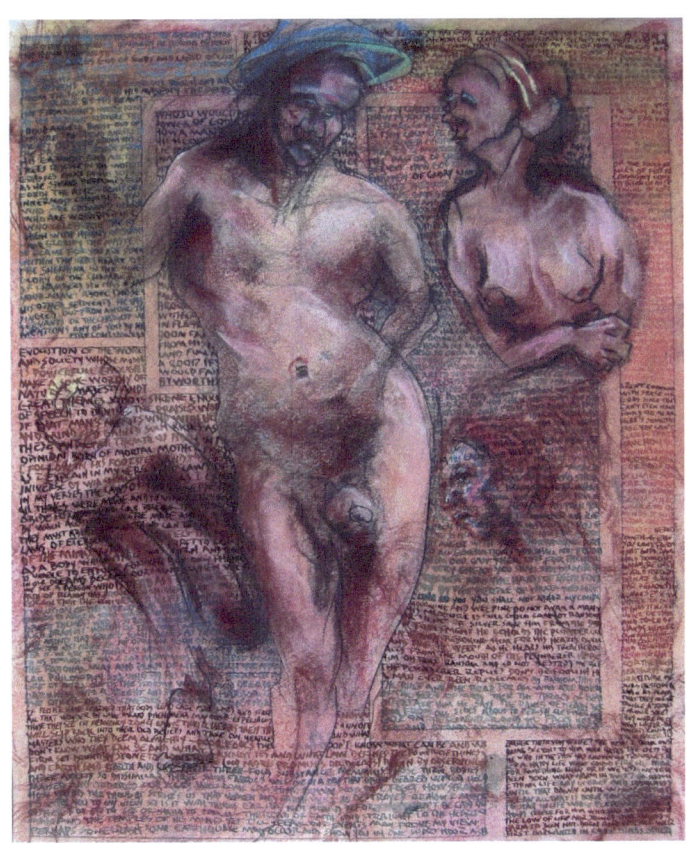

but since there is no category specific to the visual arts he presumed that the Peace Prize was the only realistic option.

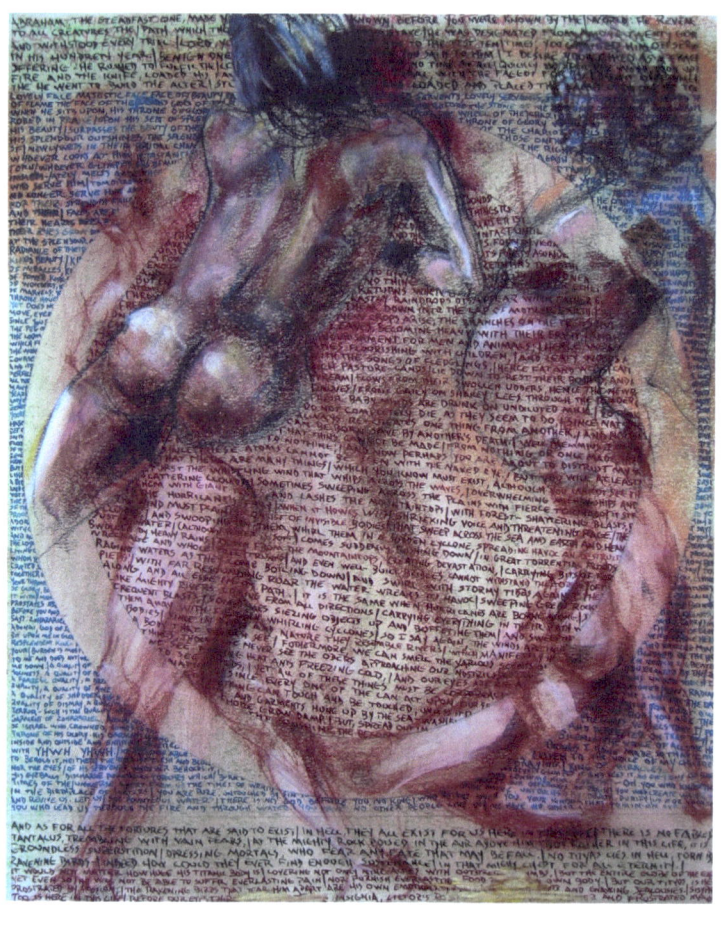

His scheme was as simple as it was absurd

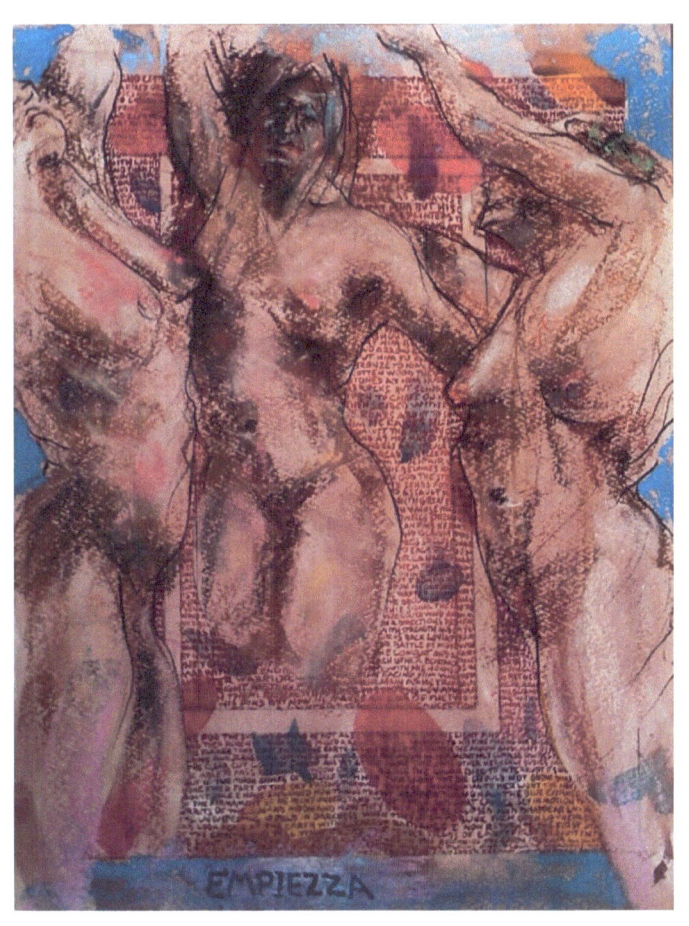

and the odd thing is, he almost pulled it off.

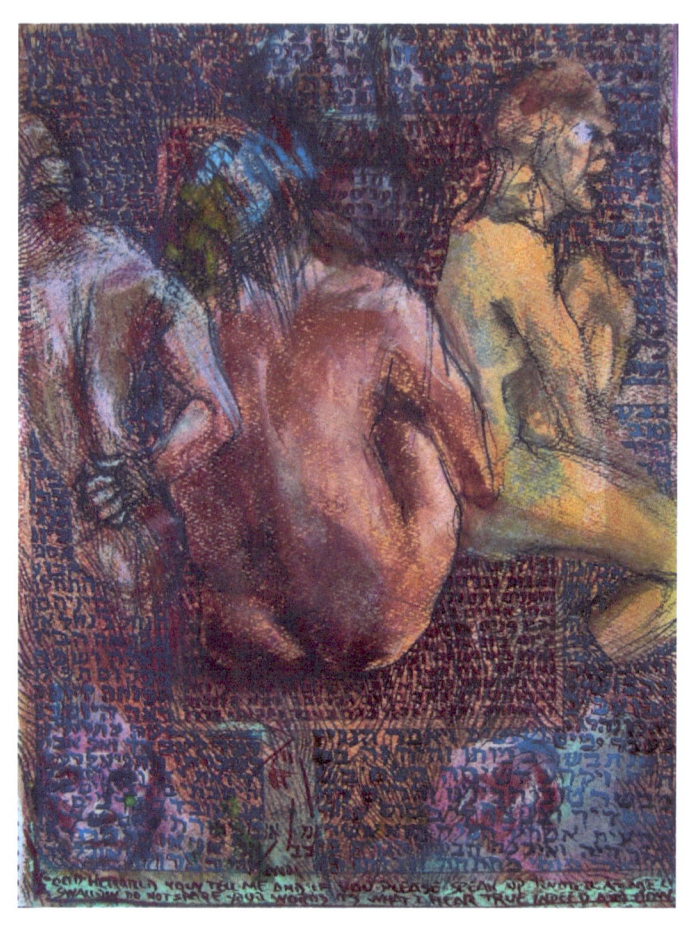

Malaspina never really took an active interest in politics - he is far too narcissistic

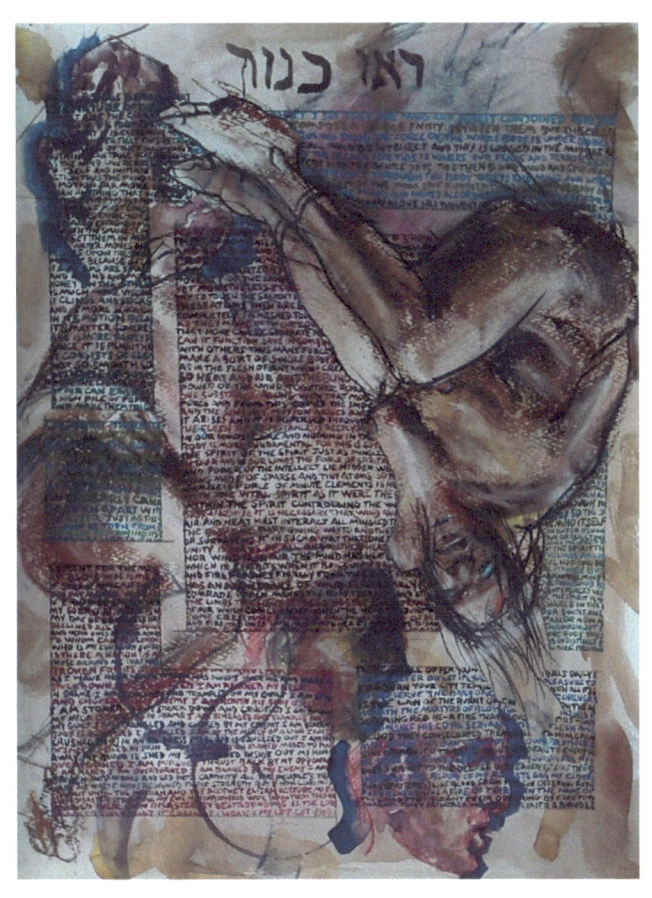

– and despite the French fashion for effete anti-Zionism he never presumed to take sides in the Middle East.

It is precisely for this reason that he hatched an unusual plan to settle the conflict between the Arabs and the Jews once and for all.

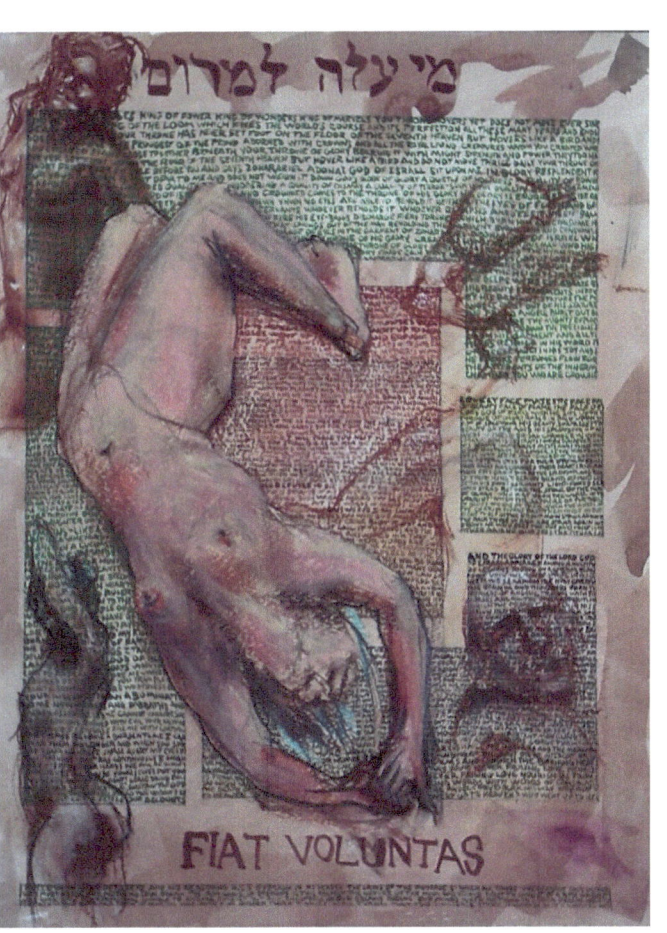

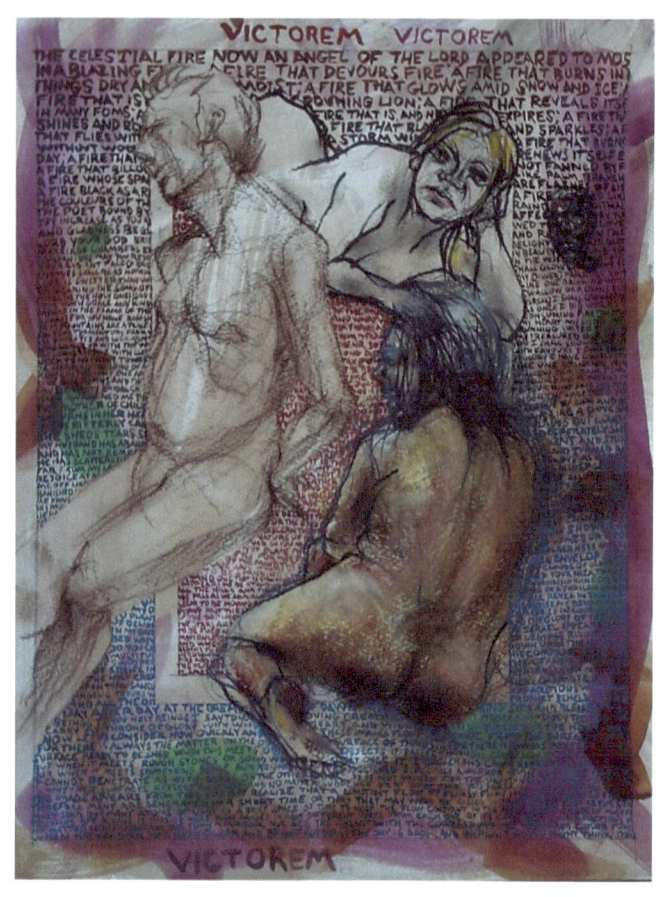

He called it Désir

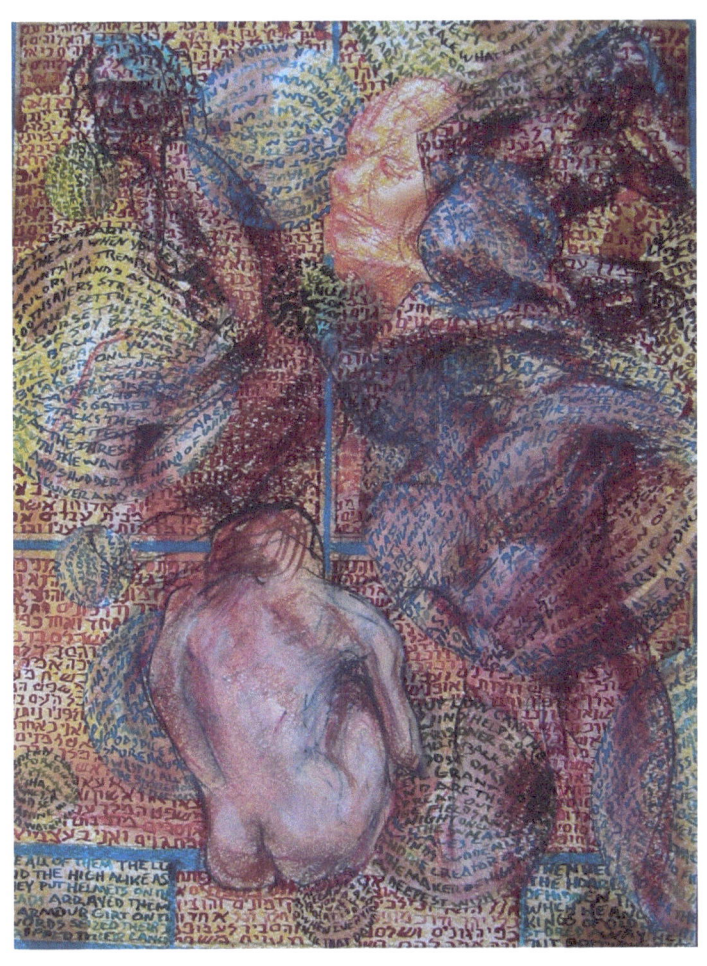

the first Palestinian/Israeli
dating service!

With one office in Jericho and another in Ramat Aviv, Malaspina's staff of twelve tireless love brokers tried to package and promote the idea of reconciliatory miscegenation. Never losing sight of his real goal, Currado hired the wily publicists of Heugot SMT to spread his quixotic gospel of peace through love.

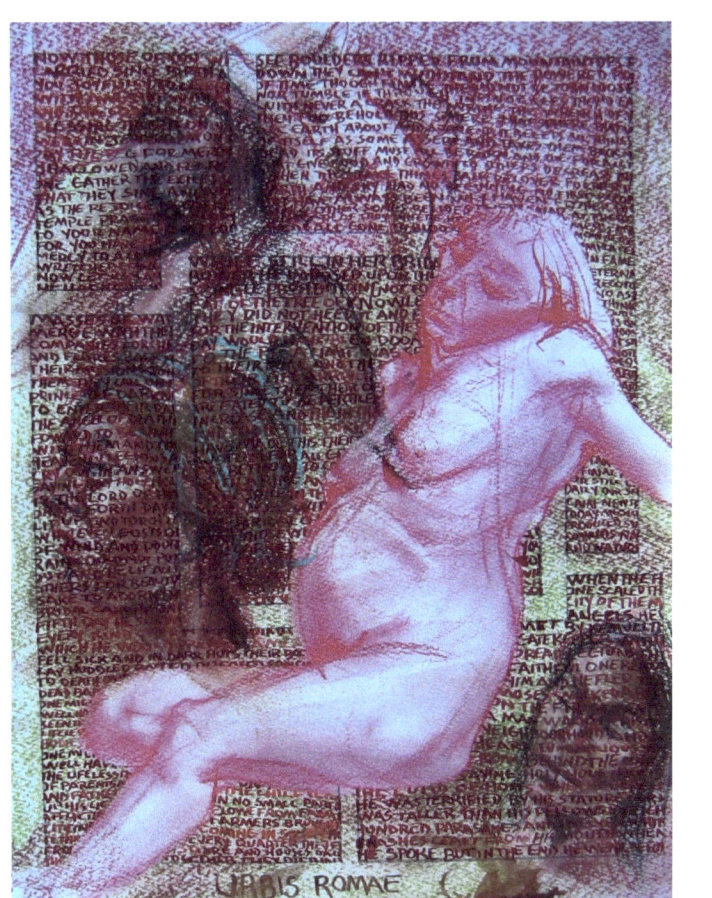

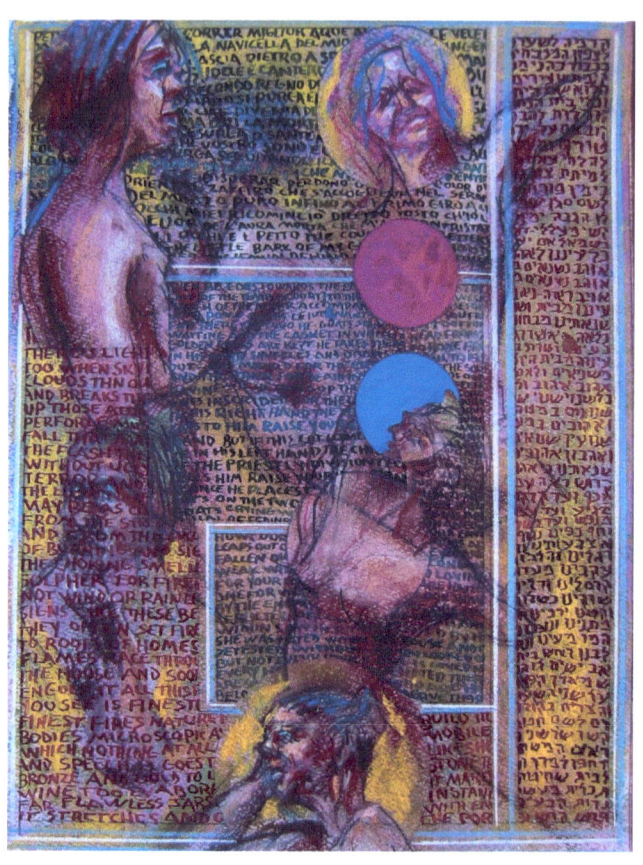

His client list included Palestinian soccer star Ibrahim Koolatim-Utim, the West Bank writer and socialite Sooha Chazava

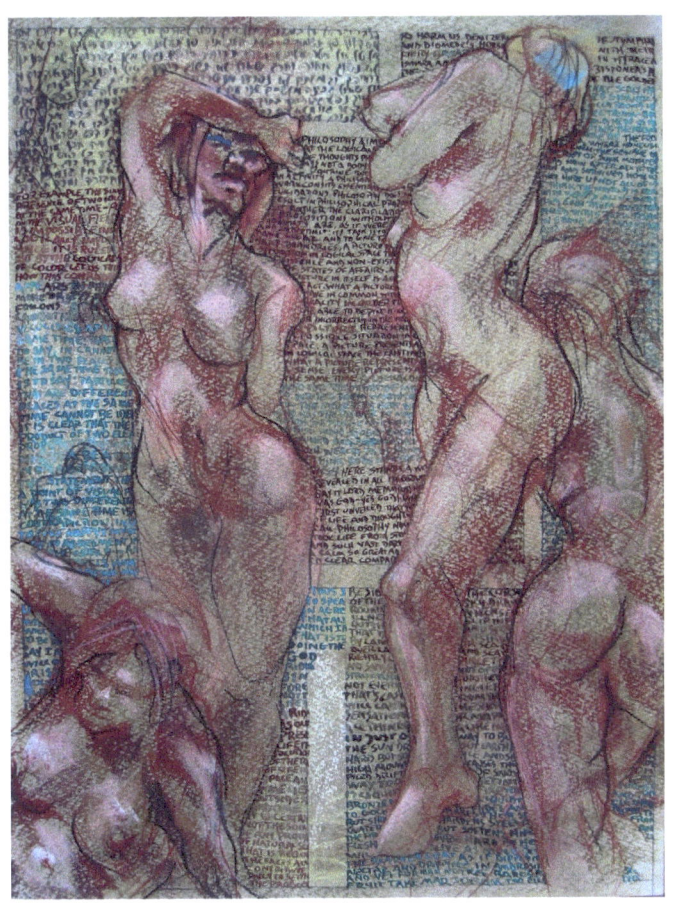

and Niri Gas-Ruah, the star of Israel's top reality program Mitachat La-Talit.

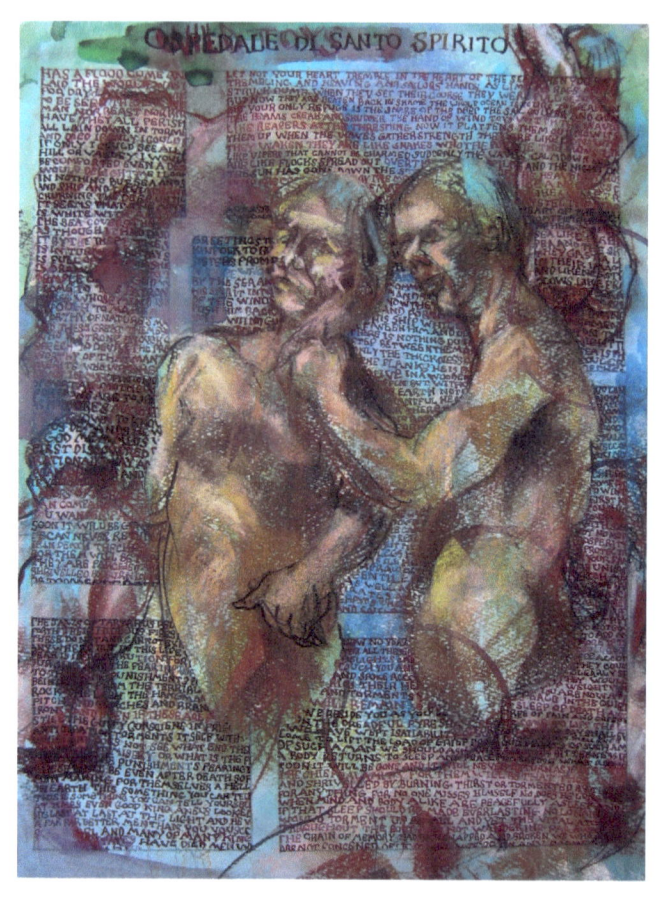

But alas, fatwas and death threats proved far too incompatible with concupiscence.

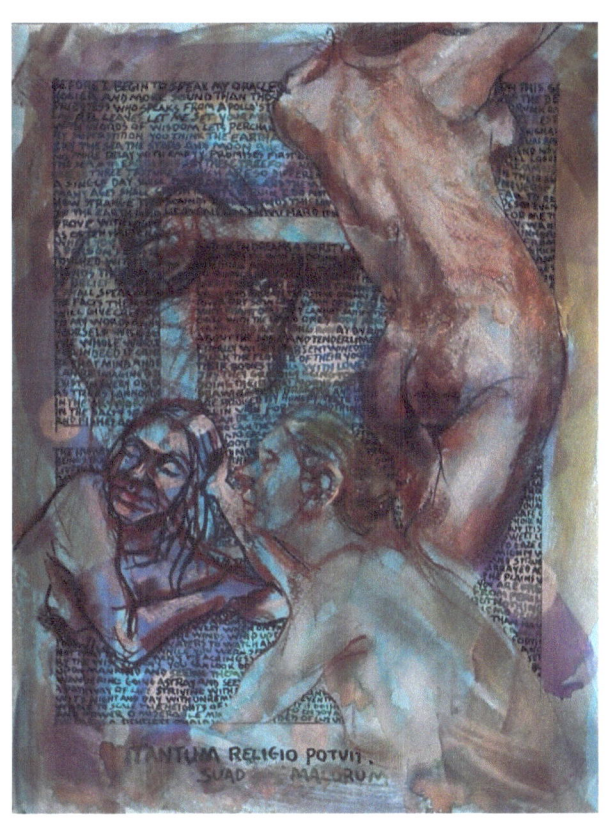

Wife swaps proved even harder than land swaps and religious taboos didn't mix well with aphrodisiacs. Currado's plan was short-lived.

For now, the Peace Prize still remains on hold.

Dahlia Danton 2015

www.ingramcontent.com/pod-product-compliance
Lightning Source LLC
Chambersburg PA
CBHW041617180526
45159CB00002BC/892